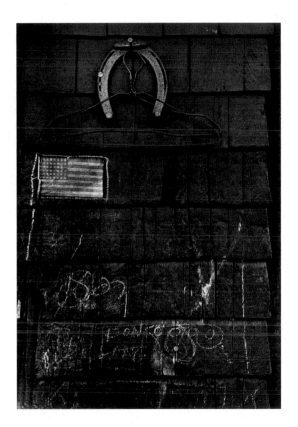

PICTURES COME

FROM PICTURES

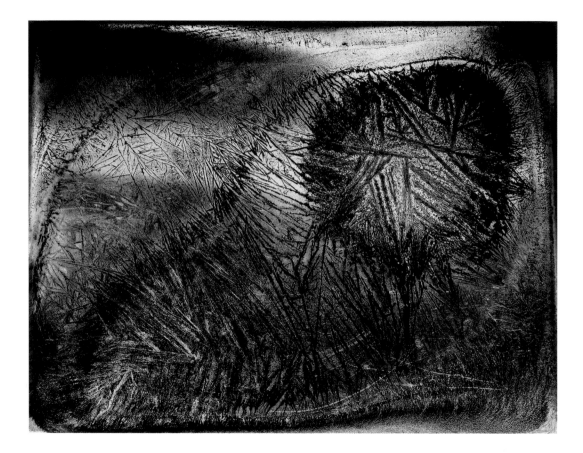

# CARL CHIARENZA
# PICTURES COME FROM PICTURES
## Selected Photographs 1955–2007

David R. Godine · Publisher · Boston

First published in 2008 by
DAVID R. GODINE · *Publisher*
Post Office Box 450
Jaffrey, New Hampshire 03452
*www.godine.com*

in association with

University of Richmond Museums
28 Westhampton Way
Richmond, VA 23173
http://museums.richmond.edu

page 1: *Interaction — Locomotive #6, 1957*
page 2: *Sulfite Lion, 1959*

Photographs copyright © 2008 by Carl Chiarenza
Preface copyright © 2008 by Richard Waller
Introduction copyright © 2008 by N. Elizabeth
Schlatter

LIBRARY OF CONGRESS
CATALOGING-IN-PUBLICATION DATA
<TK>

FIRST EDITION · *Printed in Spain*

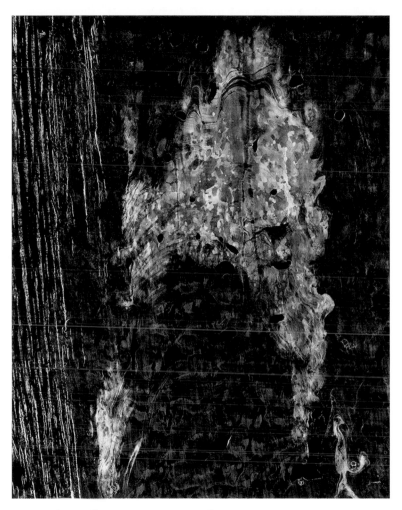

*Ice on Chappell's Barn, Honeoye Falls, 1959-1960*

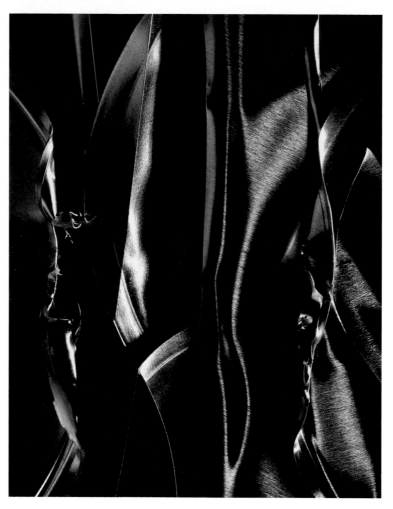

*Solitudes 71, 2004*

# DIRECTOR'S PREFACE

The University of Richmond Museums are pleased to participate in this publication of work by contemporary artist Carl Chiarenza. The book coincides with the presentation of the exhibition *Peace Warriors and Solitudes: Recent Photographs by Carl Chiarenza*, on view from July 15 through October 5, 2008, at our Lora Robins Gallery of Design from Nature.

As one of the preeminent photographers of the twentieth and twenty-first centuries, Chiarenza has influenced not only the practice of art but also the study and promotion of photography inside academia and beyond. Collected by major museums throughout the world, Chiarenza's work has always been innovative and unconventional. His impressive œuvre is even more relevant today with the renewed interest in abstract photography and process-oriented techniques. As a scholar and critic, Chiarenza's writings likewise remain vital to the history of photography, especially his landmark monograph on Aaron Siskind, published in 1982.

This book presents several images that may be recognizable to those familiar with his work, as well as photographs that have never been published before. Together, his images and the insightful essay by N. Elizabeth Schlatter, Deputy Director and Curator of Exhibitions, University Museums, provide a thoughtful look at Chiarenza's lifetime of creating art.

At the University of Richmond, our special appreciation goes to Dr. Edward L. Ayers, President, and Dr. Andrew F. Newcomb, Dean of the School of Arts and Sciences, for their continuing guidance and support of the University Museums, comprising the Joel and Lila Harnett Museum of Art, the Joel and Lila Harnett Print Study Center, and the Lora Robins Gallery of Design from Nature. As always, we acknowledge our appreciation to the staff of the University Museums, and especially to N. Elizabeth Schlatter, curator of the exhibition of Chiarenza's photographs organized by the University of Richmond Museums.

RICHARD WALLER
*Executive Director*
*University of Richmond Museums, Virginia*

# PICTURES COME FROM PICTURES

*Pictures come from pictures. We do not know who gave birth to the first – or why or how. We can speculate on the cave or on its source of inspiration; we can speculate on how the first pictures were perceived. But we can't be sure.*

CARL CHIARENZA
*Landscapes of the Mind*, 1988

Juncture, polyphony, synecdoche, and sequence – as I prepared to write this essay these words reverberated in my mind. They came from discussions with Carl and his wife Heidi as we talked about this book and a related exhibition project for the University of Richmond Museums, as well as from other essays about Carl's life and art.

Each word suggests some form of connectedness. The concept of presenting plurality while retaining singularity comprises the underlying theme of this publication. Carl and Heidi selected the photographs after reviewing hundreds of images created over the artist's lifetime, ranging from some of his earliest pictures of Rochester and its environs in the 1950s to collage images made as recently as 2007. While several factors influenced their choices, ultimately the combinations presented here reflect an intimate and intuitive knowledge of Carl's work.

How else can one explain the successful pairing of "Untitled 113, 2002" (p. 30) and "The Glowing Knot, c. 1961" (p. 31)? These two images were created forty-one years apart yet they echo one another with their lush tonality and defining lines and forms. The entire first grouping of pictures in the book holds together thematically and visually despite spanning the years 1955 to 2002, bridging the period in Carl's career when he moved from outside to inside the studio, from nature to man-made to artist-made.

This publication demonstrates that over the past five decades Carl has been engaged in an aesthetic trajectory, a trajectory that had tangents and twists yet always remained faithful to an unnameable truth. This is hardly uncommon among artists, but possessing the luxury to examine and reflect upon threads running throughout a lifetime of artwork reveals a personal and artistic commitment that may not be obvious or tangible otherwise. Hence the importance of the connectedness not only in ascertaining the strengths and differences in Carl's work over time, but in observing where his imagery comes from and how it always relates to another picture, even if the source material for the pictures varies radically.

> JUNCTURE: *the line or point where two things are joined. A point in time, especially a critical turning point.*

When discussing their lives and artwork with contemporary artists, I am often struck by their realization of significant turning points in their aesthetic development. Such junctures can be modest, almost unnoticeable at times, whereas other experiences seem to slam the artist into another realm of creativity altogether. The art made during these critical moments may not be great, or even good, but it is often a necessary passageway into discovery.

Carl's critical juncture took place in 1979, during which time he served as chair of the department of art history at Boston University. The Polaroid Corporation, located in Cambridge,

invited him and several other photographers to try out their new 20 x 24 camera that was limited to producing color photographs. Only Ansel Adams was allowed to take the large camera out of the studio. Accustomed to working outdoors, Carl found himself challenged to find something he could bring to the camera. Hence the creation of the collages of detritus used as still life that have effectively dominated his work ever since.

The first images made at Polaroid were, in Carl's words, "terrible." After experimenting with the collages in his own studio using Polaroid 4 x 5 color film, he realized he was creating what were effectively black-and-white images made in color. Switching to black-and-white film, which he had already been using outdoors, was not just a natural choice, but also one that allowed him to control and transform the nature of his subject matter, removing what were for him, the distractions of colors.

Ever since this juncture of accident and practice, Carl's photographic process has remained remarkably the same while simultaneously incorporating endless experimentation. He usually enters the studio without a preconceived idea and basically "plays around" with materials like bottle caps, envelopes, cardboard, foil, random scraps of paper, and other readily available debris until something interesting forms. He manipulates the light hitting the collage and may crop the image or otherwise alter the composition as seen through the camera. Although he initially photographed the collages attached to the wall, he quickly realized that having the collage components rest on the horizontal surface of a copy stand afforded much more freedom in terms of choosing materials for the collages, moving and changing these materials, and altering the lights and setup to better suit his overall fluid process of image-making.

Carl's aesthetic choices continue in the darkroom. Dodging, burning, manipulating the light that hits the paper and the contrast and tonalities of the print, altering the temperature and time of the developers — these are all tools in his craft as much as the camera itself.

He has said that it is almost impossible to make two identical prints because of all the decisions and steps that inform his final picture.

> POLYPHONY: *the simultaneous and harmonious combination of a number of individual melodic lines.*

Although the visual elements of Carl's studio photographs seamlessly meld into the overall composition, certain fragments are recognizable, such as the edge of a patterned security envelope that comprises part of the "landscape" in the triptych "Untitled, 251, 250, 255, 1993" (p. 92). But the objective behind Carl's studio work is not simply to cleverly disguise the subject matter but rather to create an interesting picture out of these mundane materials. "What is this a photograph of?" is not the intended response. A better question would be "What is this?" as in, what is in front of me, what do I see and how is it shaped? How does the image itself inform my viewing of it?

With this approach, Carl flatters both his still life and the medium of photography itself. Through the lens and Carl's darkroom processes, objects that are extremely simple and typically possess little value – monetary or aesthetic – such as a piece of foil and a wire, become something new and epic, or perhaps modest, but always sensual and emotive. These are images that can only be made as photographs, not as paintings, prints, drawings, or by any sort of digital process.

When thinking of comparisons in other media, the bottles and boxes depicted by Italian painter Giorgio Morandi come to mind as do the impeccably lush intaglio prints by the American artist Robert Kipniss. Yet while these two artists demonstrate a respect for, a love for, and an incomparable talent in revealing their chosen material's inherent strengths, their work remains grounded in their personal observation. Carl's photographs are not about

"seeing" in the straightforward sense, or even "seeing" through the camera itself. Rather they are about "seeing" the photograph in front of you, which is a unique image created through the combination of unrelated objects – the collages Carl constructs – and the transformative process of photography.

Within the history of photography, this concept of "looking at" versus "looking through" has been a long-held debate, fueled most recently by the advent of digital media. In the catalogue for the 1978 exhibition "Mirrors and Windows," MoMA photography curator John Szarkowski opined on this perceived dichotomy of the medium being used as a mirror of self-expression or as a window through which events and appearances are recorded. Yet Carl has always maintained that the assumed veracity of a photograph is false and that all photographs are abstract.

> When it was invented in 1839, people thought it captured reality, but photos have always been pictures just like any other man-made picture, as in painting for example. A newspaper photo doesn't represent how the human sees, because it's usually in black-and-white, created with only one unmoving viewpoint, as opposed to two moving eyes and a moving body, cropped from an active three-dimensional world and set into a frame. Once you come to that realization, you're free to do anything.
>
> interview with the artist, Focus magazine, April 2006

Of course one could argue that some pictures are more abstract than others. And within that subjective grouping are most famously Alfred Stieglitz's "Equivalents," Edward Weston's close-ups of natural forms, Harry Callahan's studies of weeds in the snow or sky, and much of the work of Minor White and Aaron Siskind, among countless others. However Carl's pictures

made since the 1980s differ from these by virtue of his collage-making technique. He both physically creates his subject matter and then transforms its appearance, as opposed to the "found" (yet still manipulated) imagery of Siskind's close-ups of marks on roads or White's pictures of frost on windows. Forming the collage, photographing the collage, and creating the final print are all equal and critical components of Carl's work.

> Synecdoche: *a figure of speech in which the word for part of something refers to the whole or vice versa, such as using "the law" for the police or "wheels" for a car.*

A previous author has noted that Carl relied on synecdoche for providing the overall content of his artist's book *Interaction: Verbal/Visual*, which the artist created in 1957 for his undergraduate thesis at Rochester Institute of Technology. Influenced by Minor White – one of Carl's instructors at RIT – these photographs of railroad images were created and presented in a format designed to illustrate and amplify aspects of Nancy Newhall's article "The Caption," published in 1952 in *Aperture*. A sequence of pictures of train wheels, parts, tracks, etc., was intended to represent the whole of the train, of the railroad, and of the experience of being on a train or at the station.

In later photographs, such as "Peeling Paint, Interlochen, 1958" (p. 59), "South Boston 1, 1975" (p. 33), or "Menotomy 340, 1982" (p. 85), Carl's visual content doesn't so much stand in for something greater or larger as it stands alone, a new image transformed through the medium. A few of these pictures recall the abstract photography of Siskind, whose work seemed a supportive force for Carl. Siskind later became the subject of Carl's dissertation at Harvard, which was published as a monograph in 1982.

However, like the 1957 railroad pictures, the recent series "Peace Warriors" (2003) and "Solitudes" (2004), collectively refer to specific concepts. The human forms in "Peace

Warriors" wear armor, bear arms, and are identified in a few cases as samurai, the grim reaper, Don Quixote (whom Carl views as a personal hero), or his sidekick Sancho Panza. Created out of his frustration over the war in Iraq, Carl has noted a dichotomy between the title suggesting proactive pacifism and the actions of the "characters" in the pictures. The fact that several of Carl's soldiers are shown in a frozen moment of battle – see "Peace Warrior (Samurai) 446, 2003" (p. 97) – echoes the oft-repeated and paradoxical stance by governments that peace comes through war. Solitary figures are portrayed as examples of stoic strength as in "Peace Warrior (Samurai) 7, 2003" (p. 101) or of misguided bravura and alienation as in "Peace Warrior (Don Quixote) 188, 2003" (back cover flap). These warriors represent a militia forced into a doomed exercise. Or perhaps they stand in for frustrated citizens unable to enact change upon a war-hungry, oil-greedy, elite group of policymakers and enforcers.

Upon completing "Peace Warriors," Carl found himself seeking retreat and introspection, out of which arose the "Solitudes" (p. 6, 119, 120, and 125). The jagged edges and rough textures in the figurative collages of the "Warriors" gave way to smoother, more sensuous forms. In these works, as in his earlier "Seven Settings" series from 1990 (p. 37–43), Carl conflates the foreground and background, resulting in the movement of interconnected shapes, shadows, reflections, and lines. These compositions lack recognizable content yet evoke visual and sensual connotations. In a poem about this work Carl wrote,

> Luminous and dark;
> Solitudes are, perhaps,
> Quietudes.
>
> Calm, harmonious retreats.
> Silent, yet swollen with sound.

After all, how can anyone ever truly achieve solitude, absolute seclusion, without the mind filling in the absence of others? While these abstract photographs are of "nothing" in terms of recognizable imagery, they overflow with tone, form, and texture, and thus meaning can be divined. Within "nothing" boundless contemplation is possible.

> SEQUENCE: *a number of things arranged in a particular order or connected in some way.*

Compiling artwork for any publication demands choices and ultimately the sequencing of images. Only so many photos fit on a page; the reader moves through the book from left to right; connections are suggested merely by placement of one image on one side of the sheet and another on the back. For this book Carl and Heidi found aesthetic connections between pictures that they then put into sequence in non-chronological "themes." But they both avow that the groupings made for this publication are in a sense arbitrary in that what they chose could easily be re-ordered to underscore new or different connections between the works.

This process of creating sequences recalls the responsibilities of the curator for installing art exhibitions, in which decisions of placement made one day could be completely different another day. These choices are made to highlight aspects of different artworks, yet inevitably a truly laudable exhibition yields unforeseen connections between an artist and her or his art. The sequencing of images in an exhibition or a book, however, ultimately is best experienced when completed by the viewer's individual response. Carl has said that he hopes the viewer of this publication sees beyond what he originally observed. "I want the readers not to find more of me in this book but more of themselves."

The concept of sequence informs not only this publication but also a basic tenet of Carl's philosophy about photography, which is the idea that "pictures come from pictures."

Every single image produced by anyone has a connection with another image, sometimes explicitly and other times more subtly. Even when an artist begins a new project, the ideas and choices that brought earlier work to fruition cannot be ignored completely.

In the arts, it is nearly impossible to create anything that someone hasn't seen before, due largely to our reliance upon imagery to learn and to communicate. In the aforementioned Newhall article, the author wrote,

> *At birth we begin to discover that shapes, sounds, lights, and textures have meaning. Long before we learn to talk, sounds and images form the world we live in. All of our lives that world is more immediate than words and difficult to articulate. Photography, reflecting those images with uncanny accuracy, evokes their associations and our instant conviction. The art of the photographer lies in using those connotations, as a poet uses the connotations of words and a musician the tonal connotations of sounds.*

Although Carl's pictures refute the "uncanny accuracy" that Newhall credits as photography's hallmark, he very clearly creates and then manipulates the connotations of his aesthetic language to move the viewer into the realm of the abstract.

He is a poet of the visual.

N. Elizabeth Schlatter
*Deputy Director and Curator of Exhibitions,*
*University of Richmond Museums, Virginia*

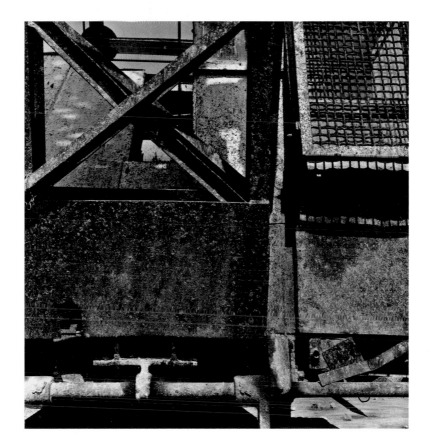

*3-D Grid Structure, Rochester, 1956*

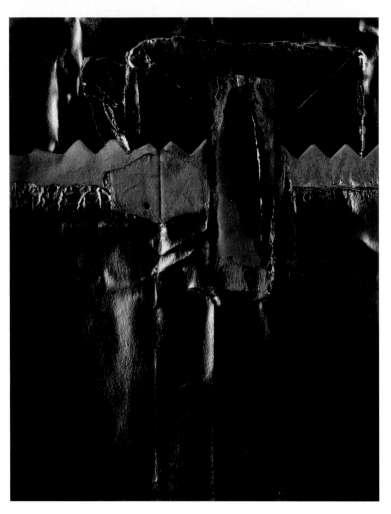

*Noumenon 236, 1987*

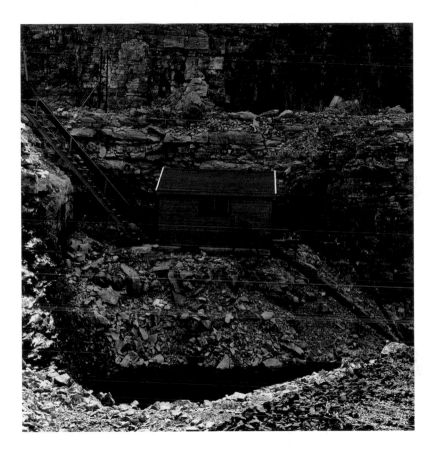

*Quarry House, Rochester, 1956*

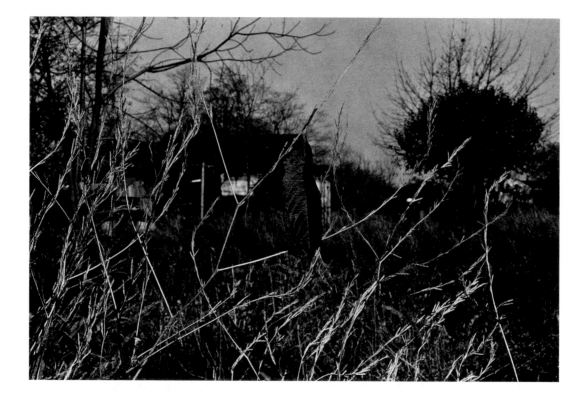

*Strange Vista, c. 1955*

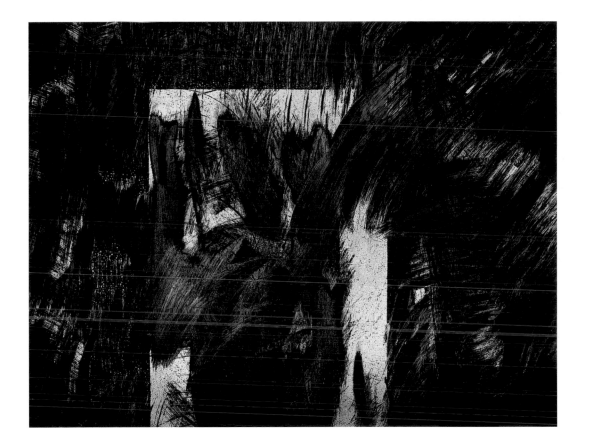

*Tucson 424, 1979*

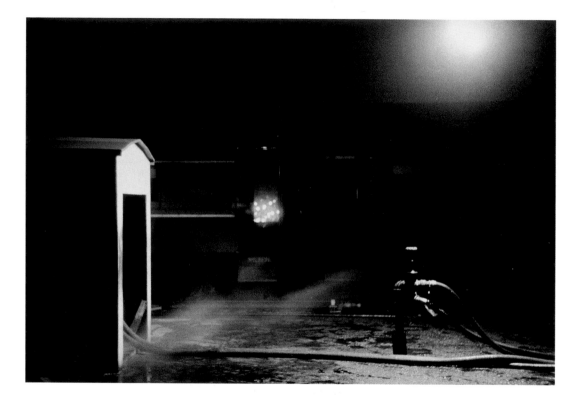

*Hoses* from *Railroad Series, Rochester,* 1956

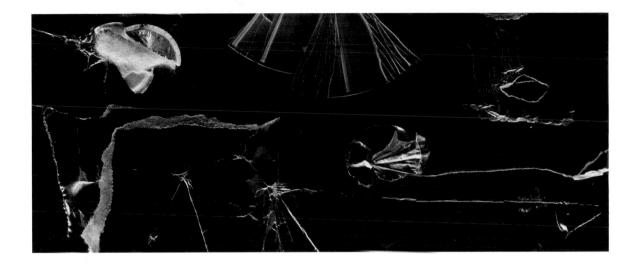

*Untitled Triptych 130, 123, 127, 1997*

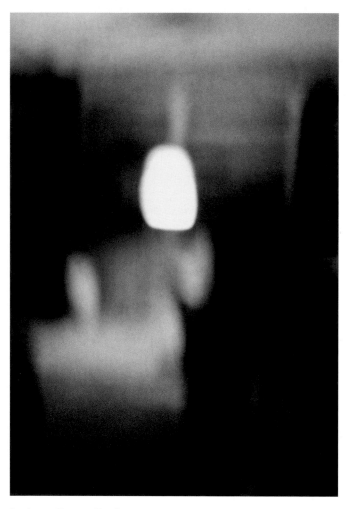

*Light in Space, Rochester, c. 1955*

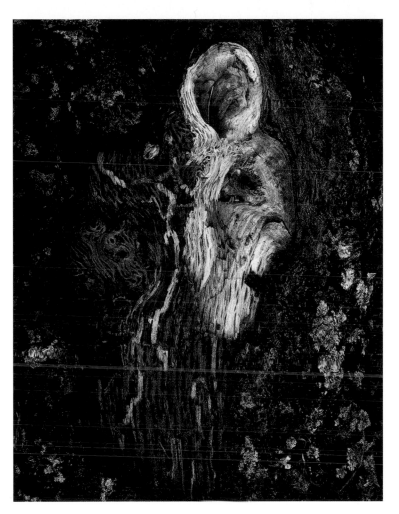

*Hooded Tree Spirit, Ipswich, 1960*

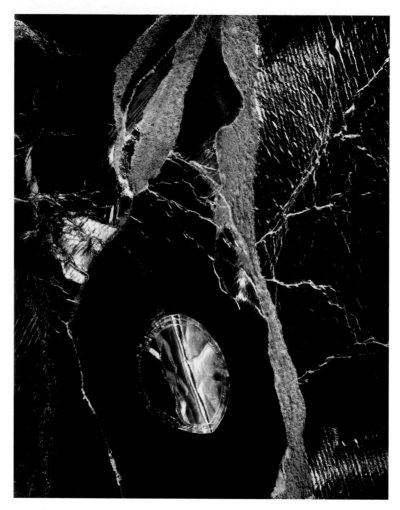

*Untitled 143, 2000*

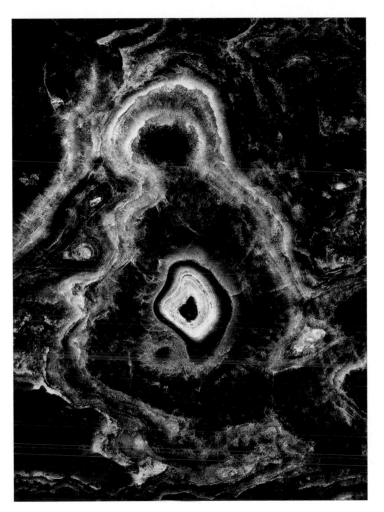

*Marble Madonna, Ipswich, 1960*

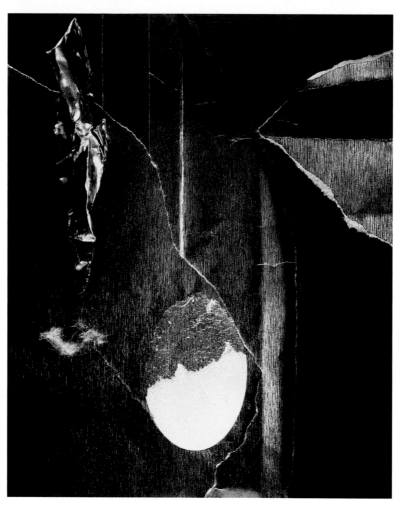

*Untitled 113, 2002*

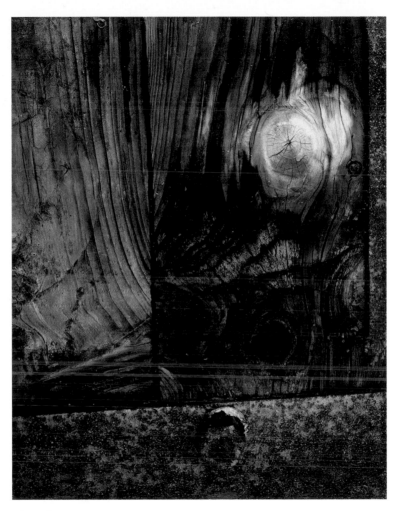

*The Glowing Knot, c. 1961*

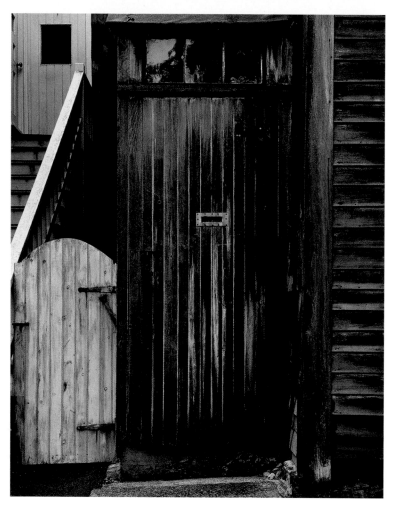

*Door and Stairs, Marblehead, 1958*

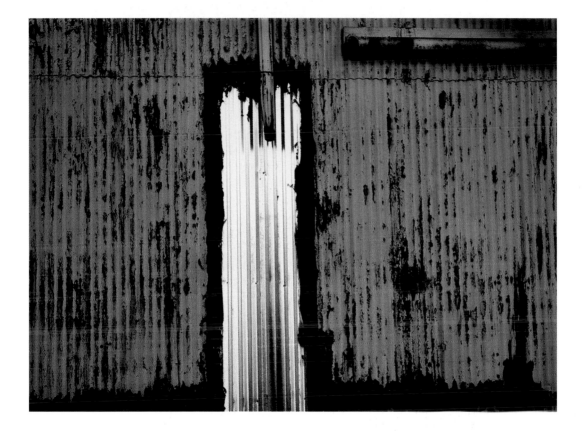

*South Boston 1, 1975*

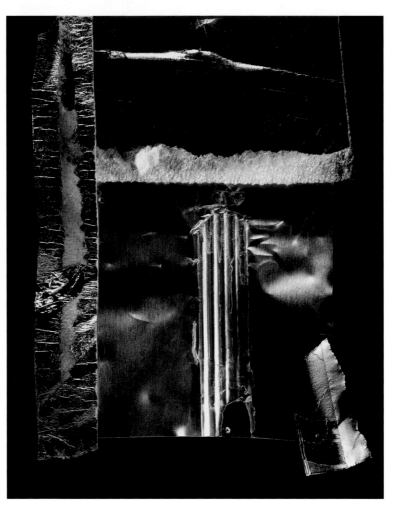

*Acropolis 76, 1989*

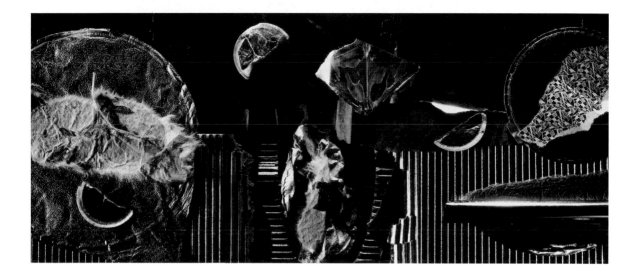

*Untitled Triptych 300, 296, 292, 1997*

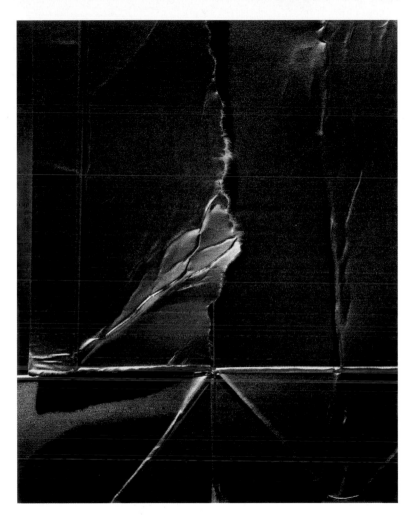

*Seven Settings #1, 1990*

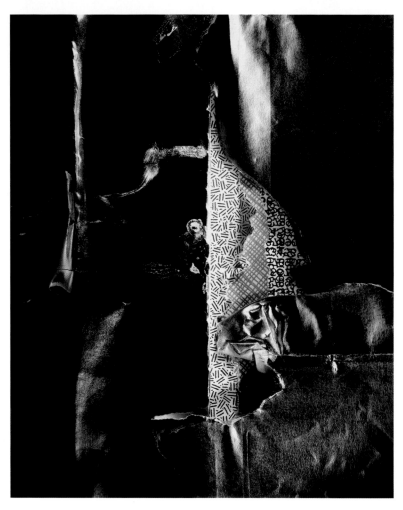

*Seven Settings #2, 1990*

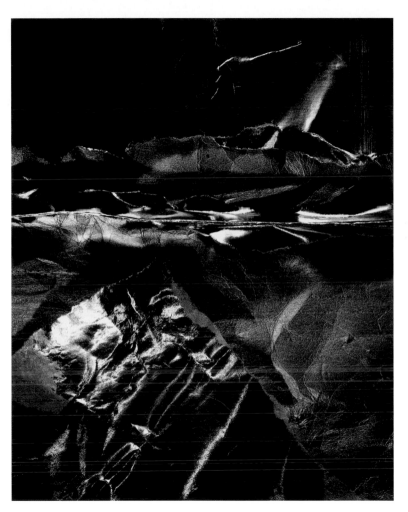

*Seven Settings #3, 1990*

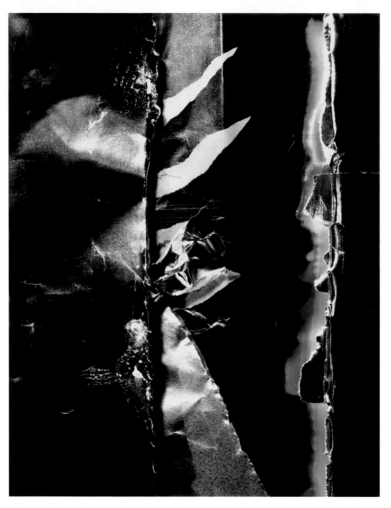

*Seven Settings #4, 1990*

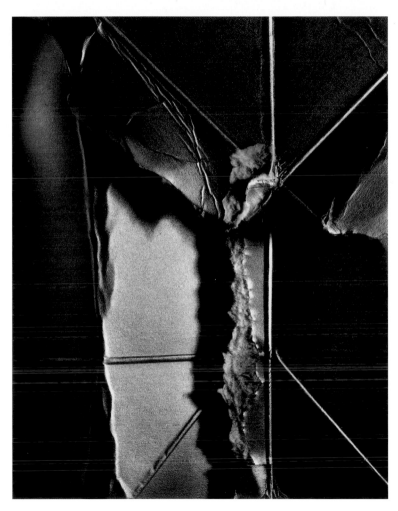

*Seven Settings #5, 1990*

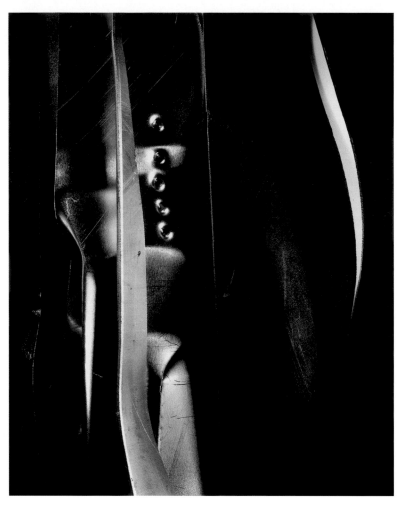

*Seven Settings #6, 1990*

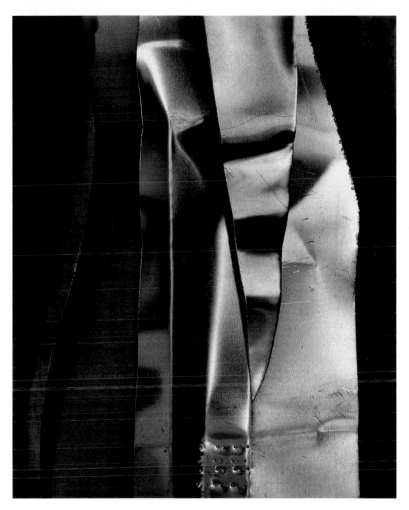

*Seven Settings #7, 1990*

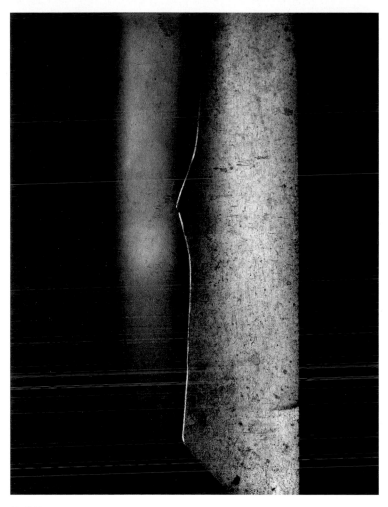

*Fall River 14, 1976*

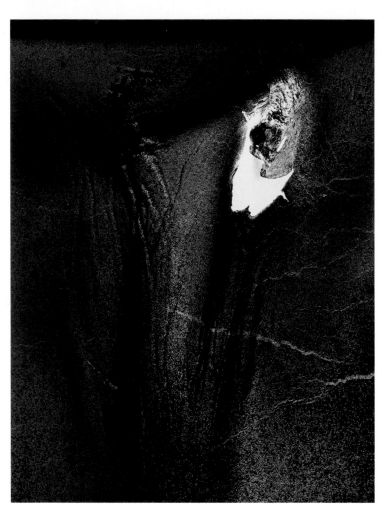

*Accabonac 4, 1979*

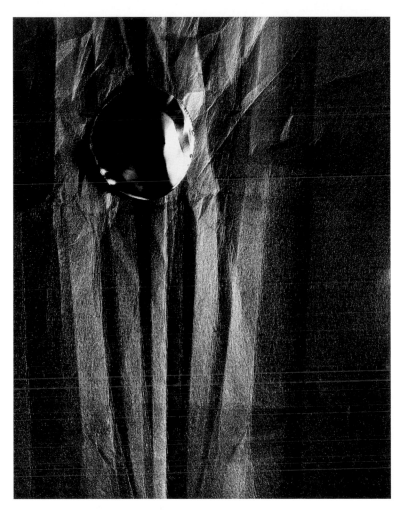

*Untitled 9, 1987*

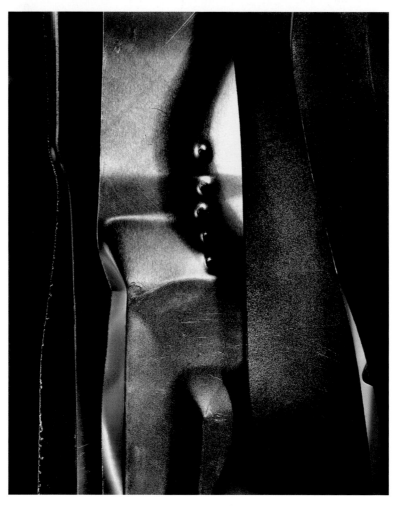

*Untitled 174, 1990*

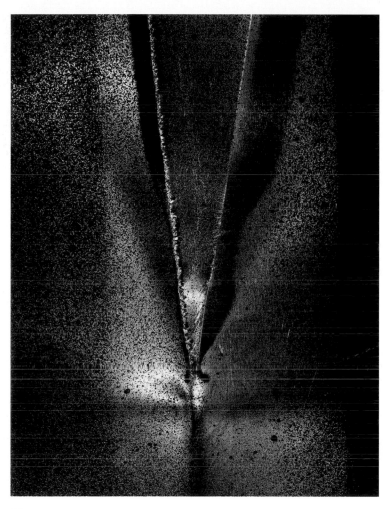

*Chautauqua 279, 1991*

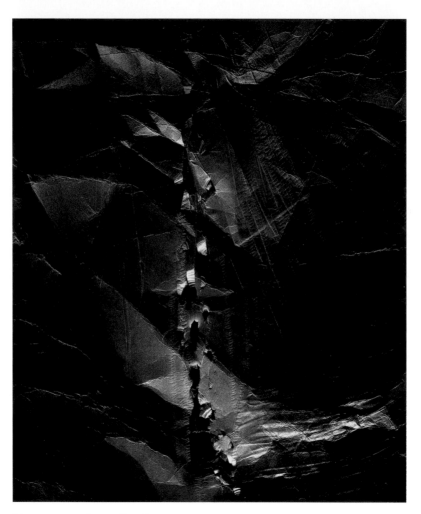

*Noumenon 382, 1984-85*

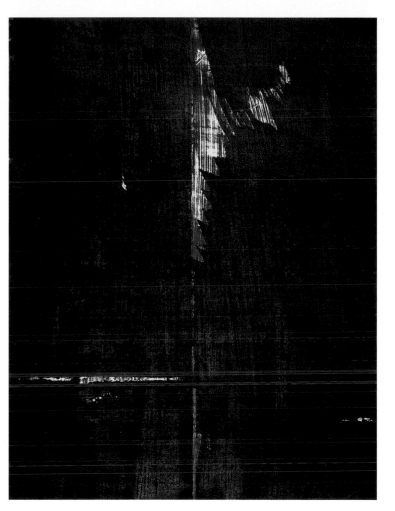

*Cambridge 10, 1974*

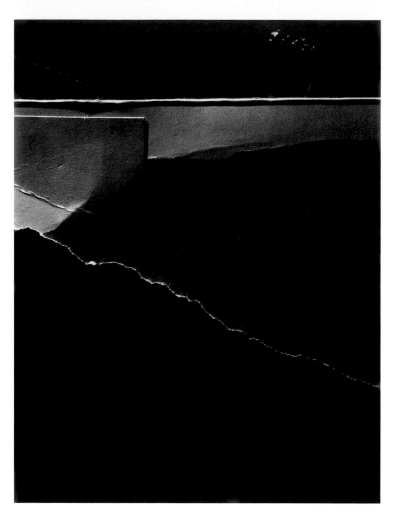

*Menotomy 61, 1980*

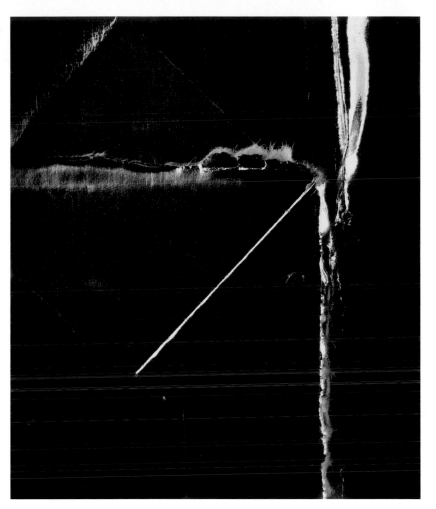

*Untitled 88, 1987*

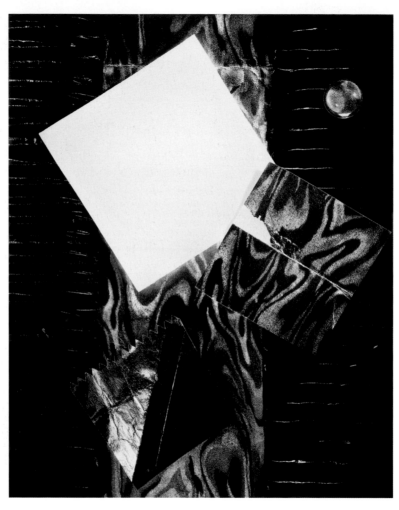

*Albers Unhinged 164, 1998*

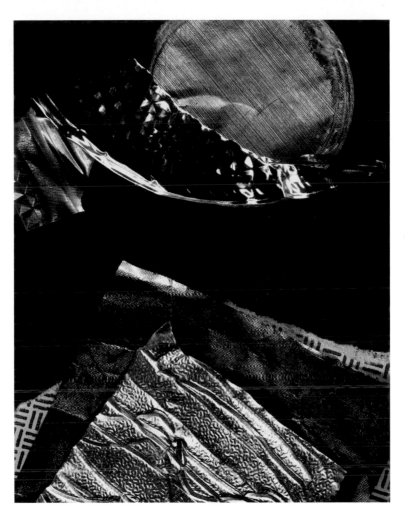

*Untitled 9, 2003*

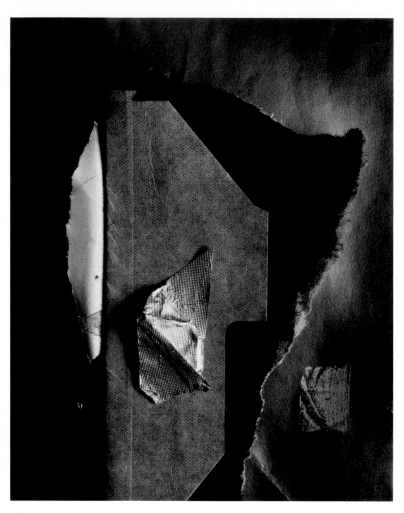

*Noumenon 148, 1987*

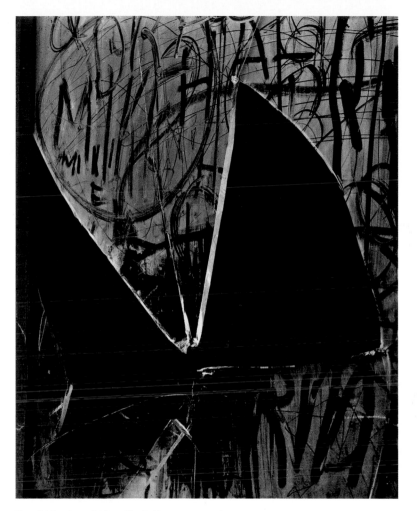

*Bat Window, West End, Boston, 1958*

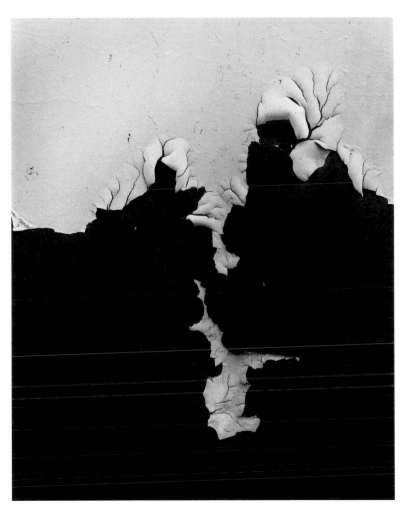

*Peeling Paint, Interlochen, 1958*

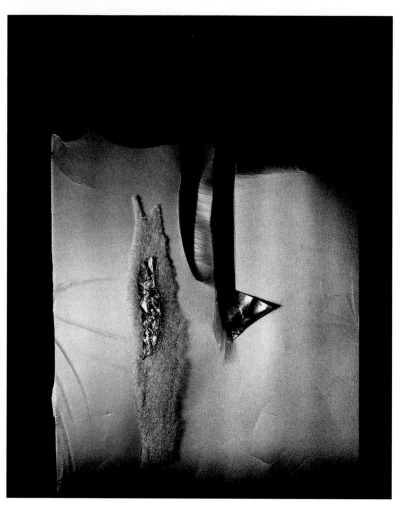

*Refrain O, 2005*

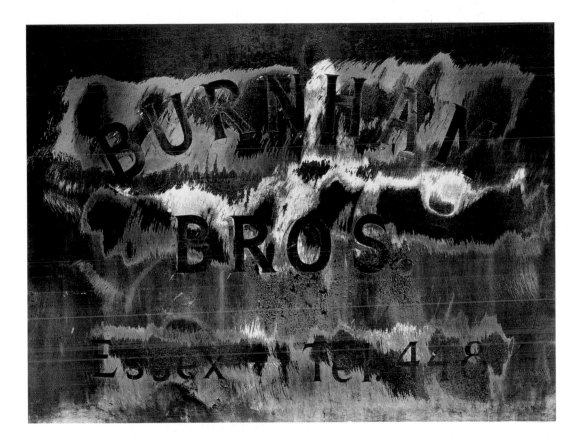

*Burnham Brothers, Truck Door, Essex, 1962*

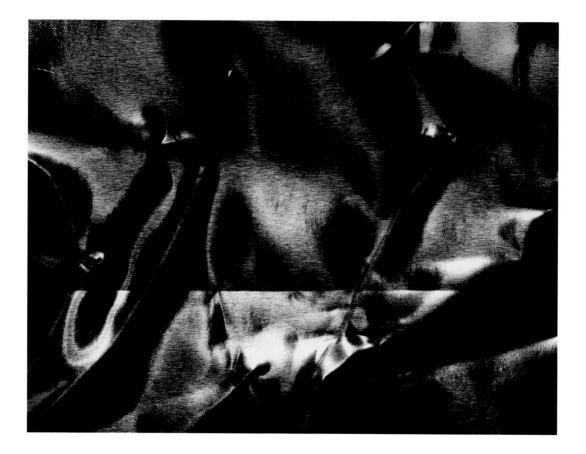

*Noumenon 372, 1984-85*

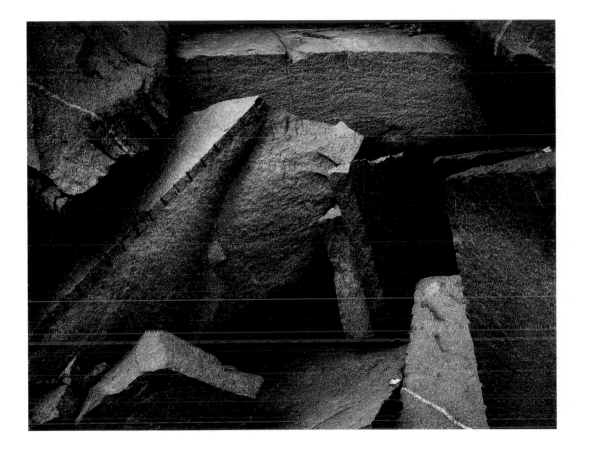

*Quarry 7, 1975*

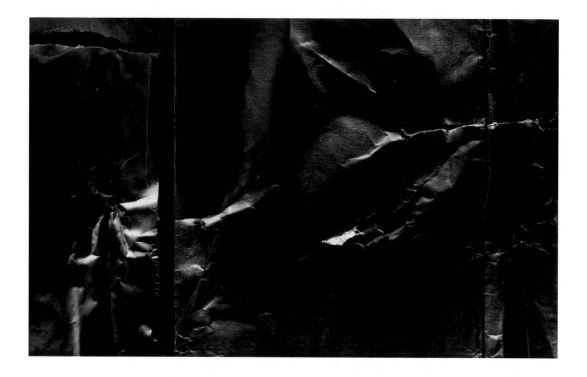

*Untitled Diptych 178, 189, 1989*

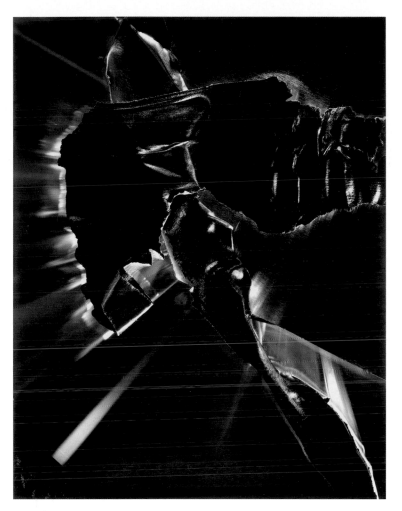

*Untitled 211, 2007*

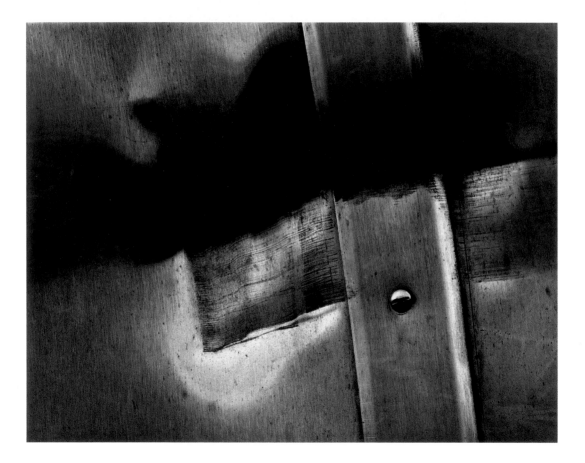

*Somerville 10, 1976*

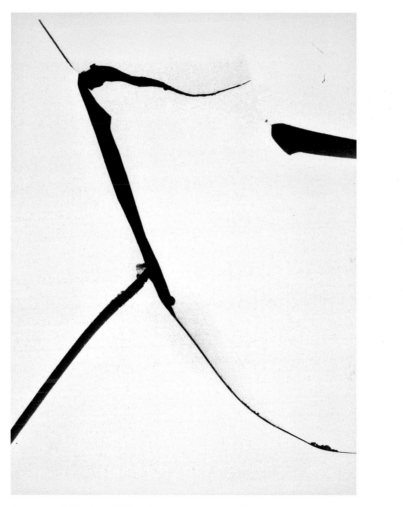

*Dancing Window, West End, Boston, 1958-59*

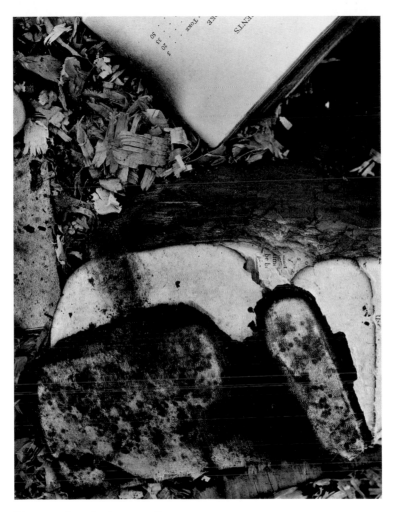

*Detritus, Interlochen, 1958*

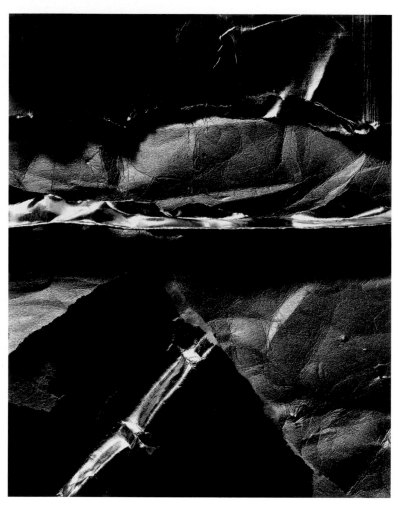

*Untitled 114, 1990*

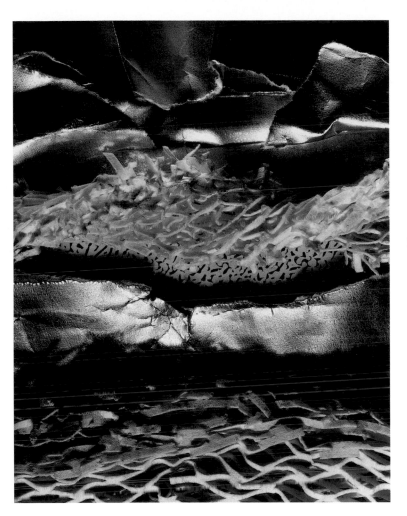

*Grotte 152, 1999*

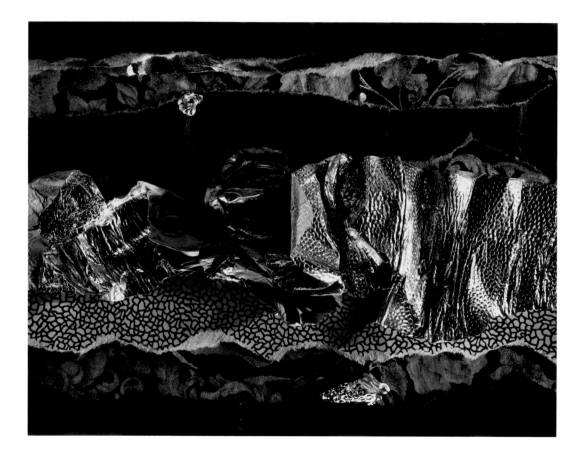

*Untitled 12, 1999*

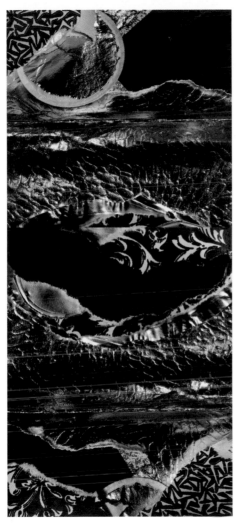

*Untitled Diptych 52, 53, 1996*

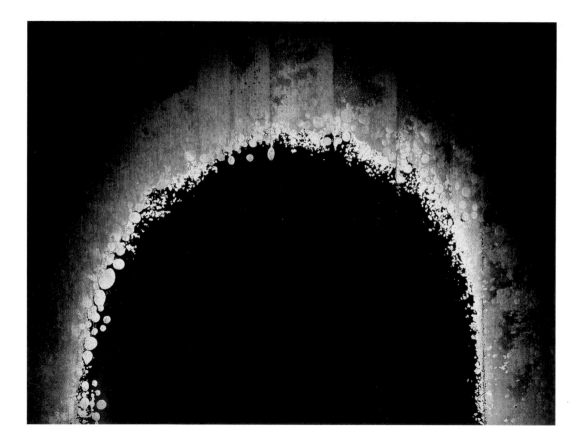

Somerville 12, 1975

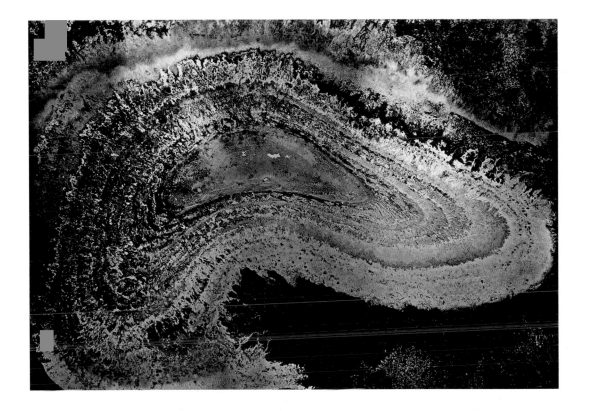

*Great Nature,* 1962

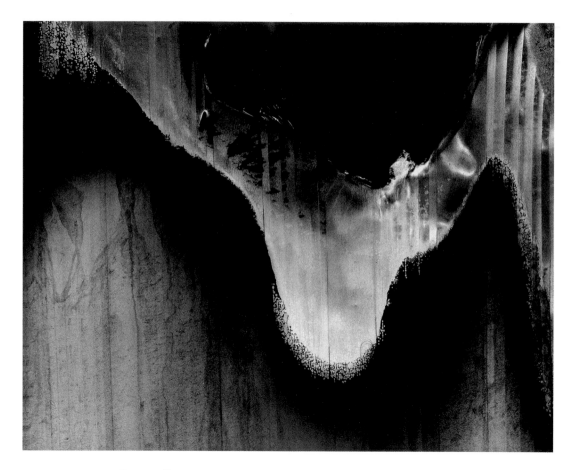

*Somerville 9, 1975*

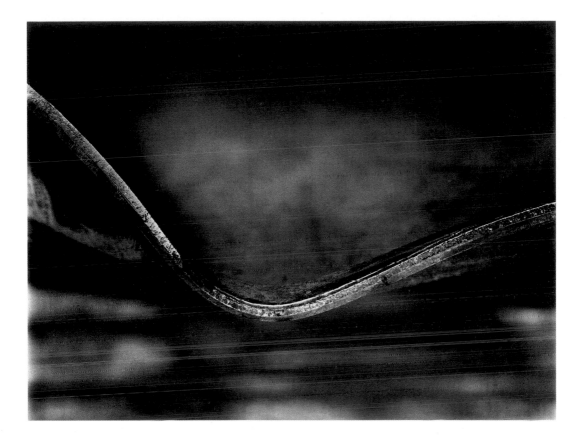

*Providence 3, 1977*

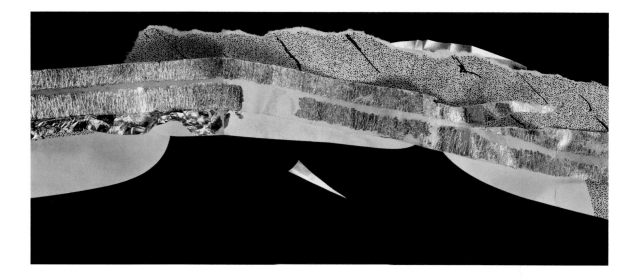

*Untitled Triptych 88, 86, 82*, 1993

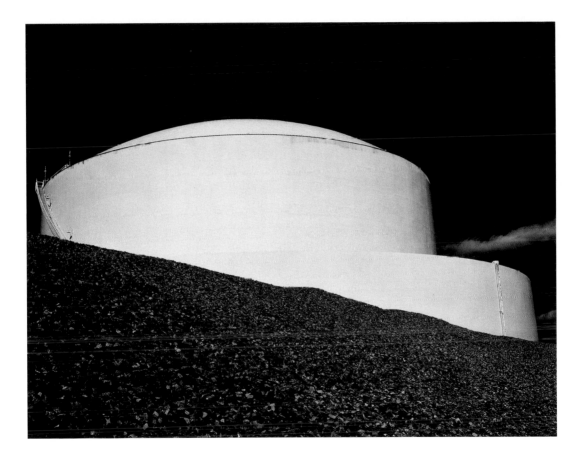

*Providence 1, 1976*

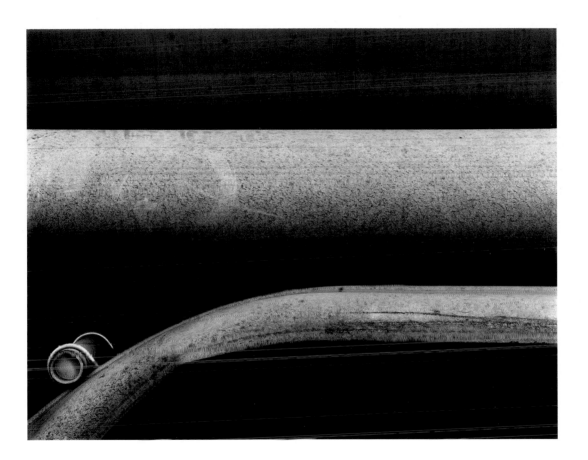

*Somerville 32, 1976*

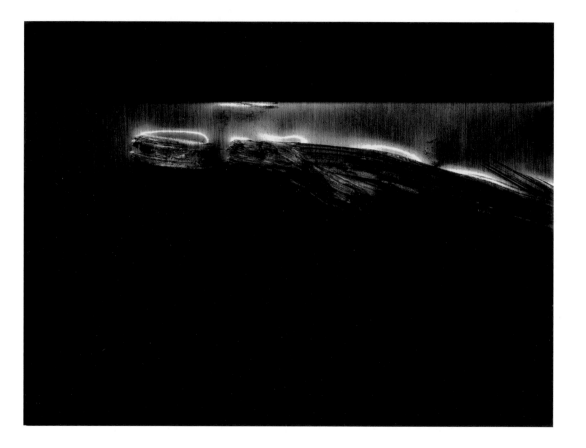

*Somerville 21, 1976*

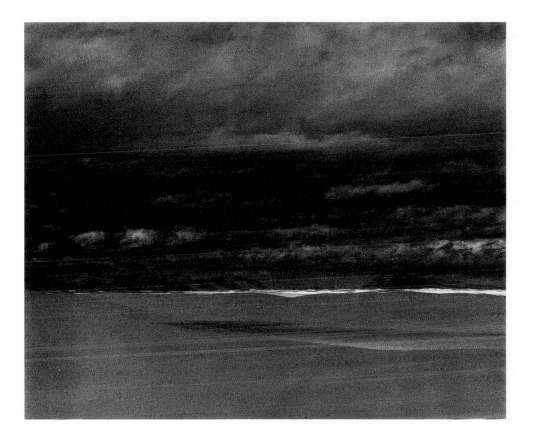

*White Sands 4, 1976*

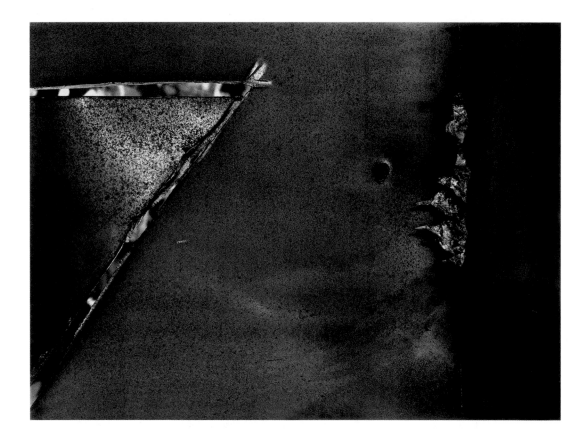

*Accabonac 1, 1979*

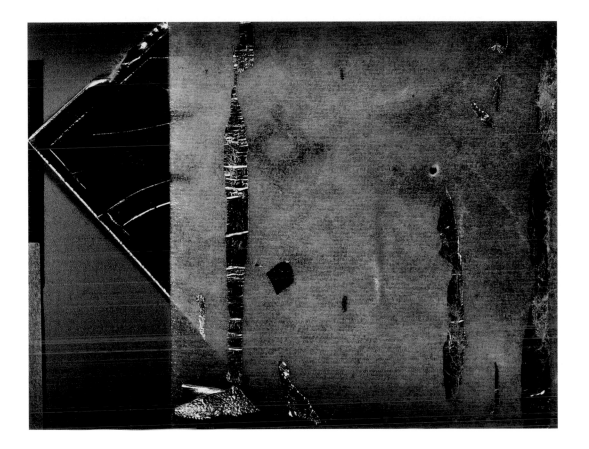

*Menotomy 340, 1982*

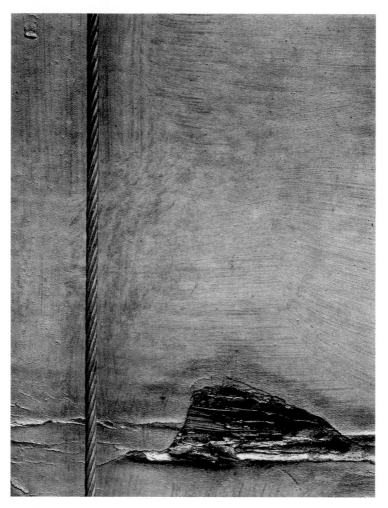

*Rockland 9, 1979*

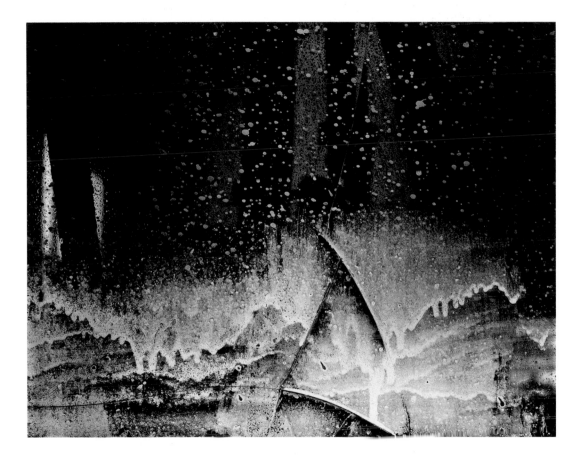

*Gloucester Window, Sailing Ship,* 1962

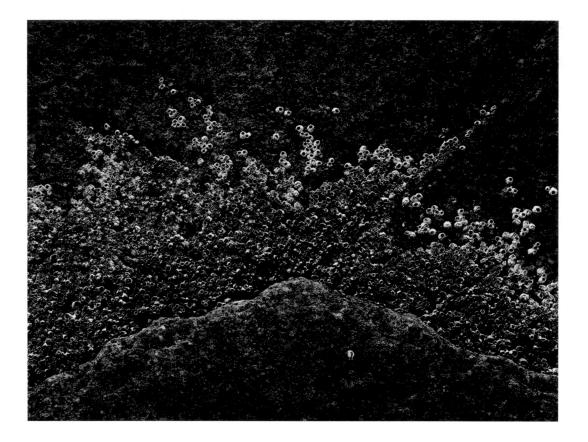

*Barnaclescape, c. 1957-65*

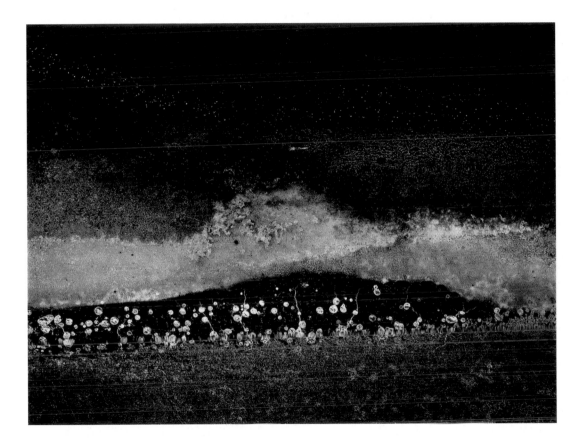

*Charlestown 42, 1976*

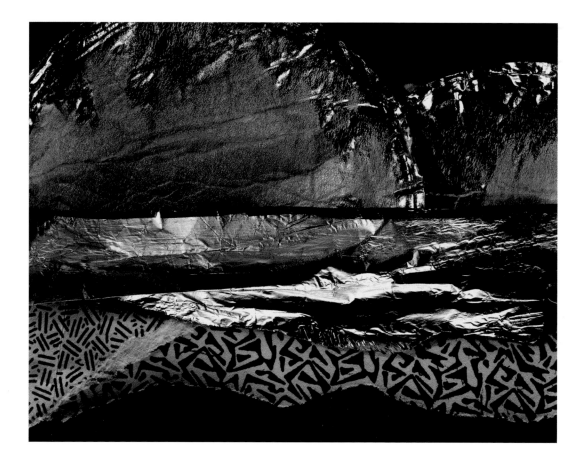

*Chautauqua 322, 1994*

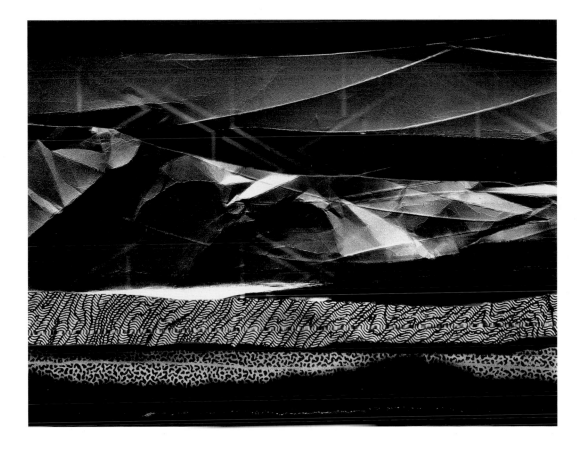

*Tenaya 265, 1991*

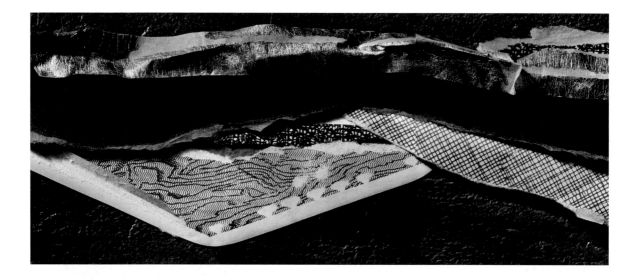

*Untitled Triptych 251, 250, 255, 1993*

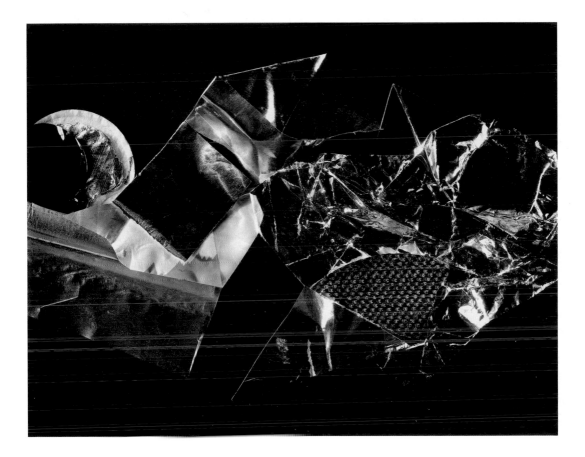

*Untitled 323, 1998*

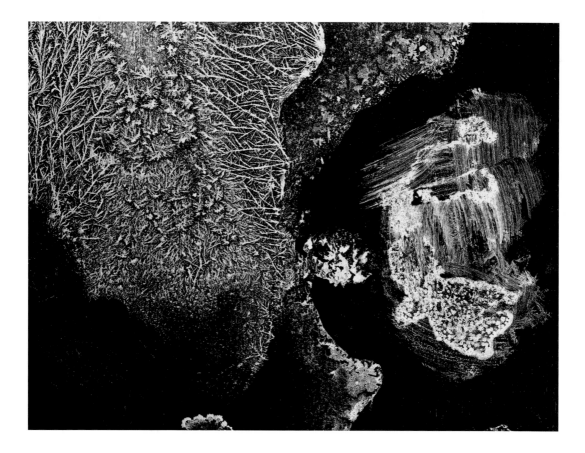

*Southeastern USA* from the *Sodium Sulfite Series*, 1960-62

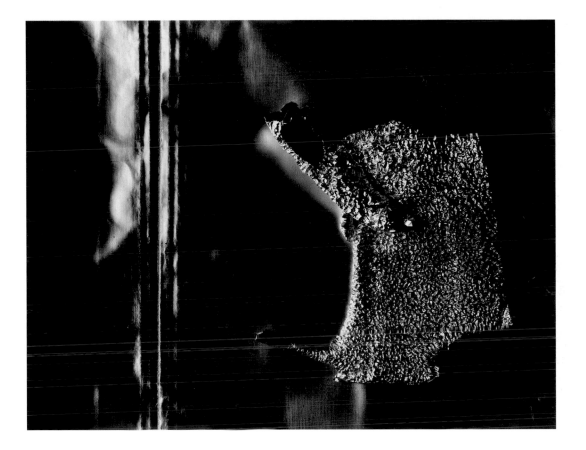

*Untitled 162, 1987*

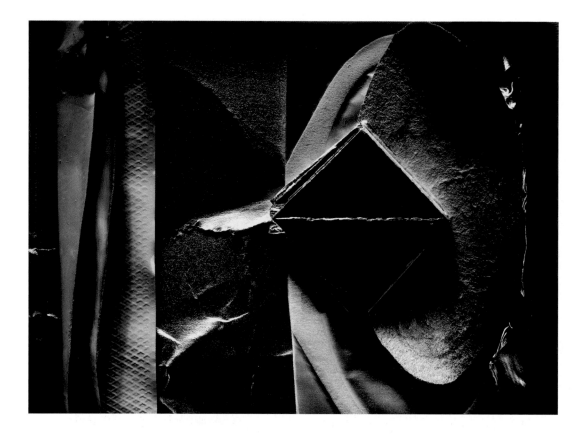

*Untitled 63, 2001*

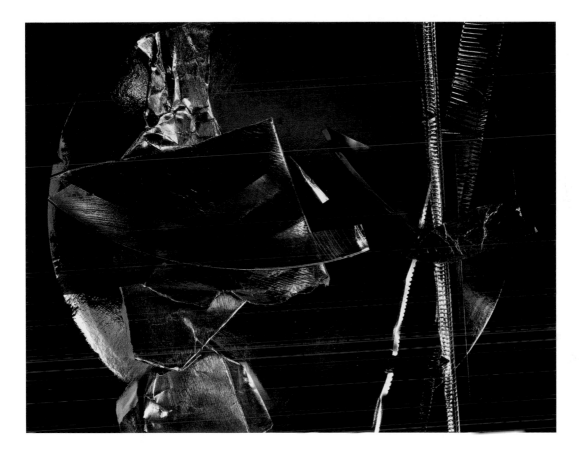

*Peace Warrior (Samurai) 446, 2003*

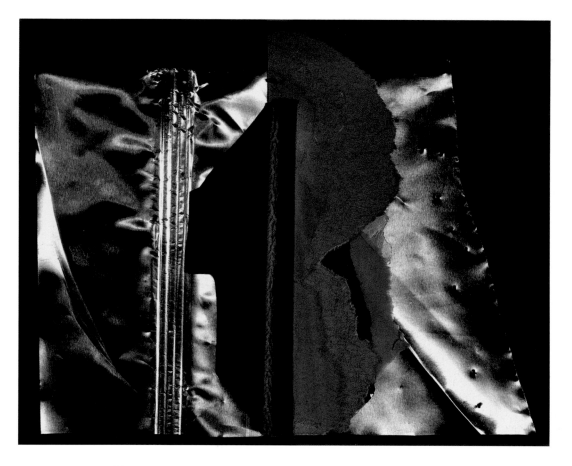

*Noumenon 25, 1986*

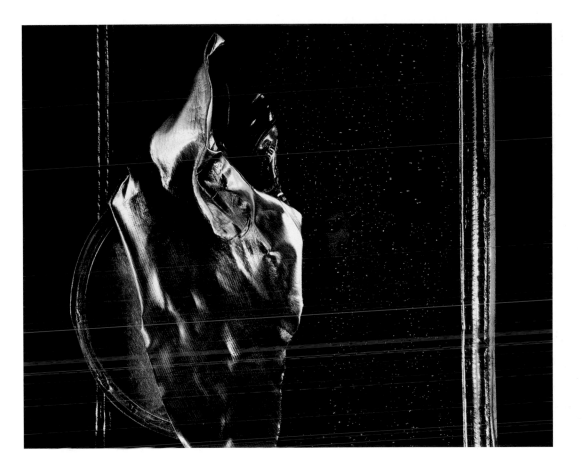

*Untitled 435, 2007*

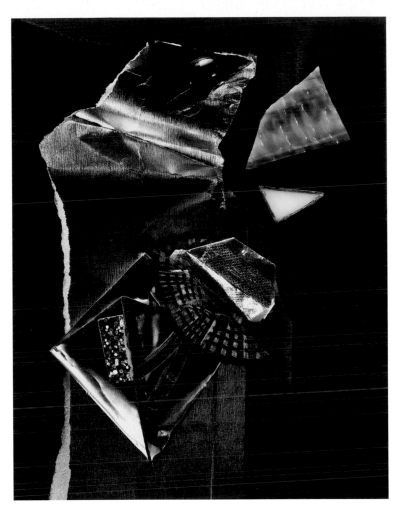

*Peace Warrior (Samurai) 7, 2003*

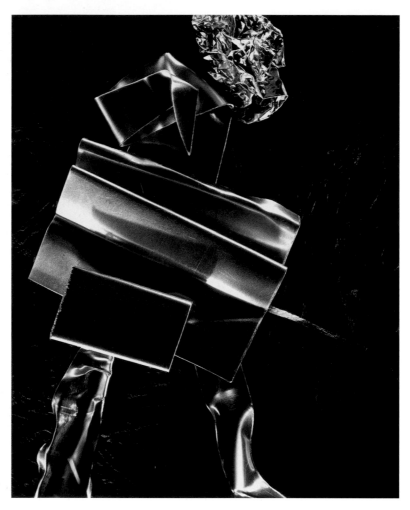

*Peace Warrior (Don Quixote) 275, 2003*

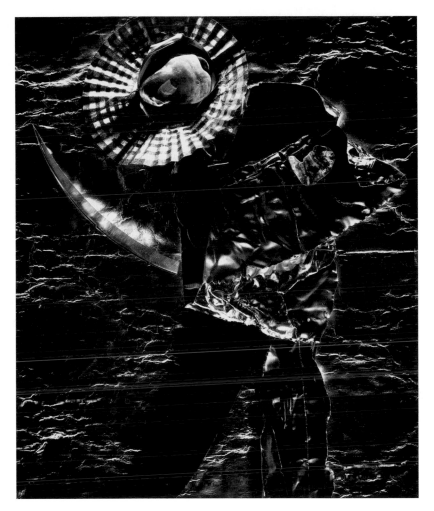

*Peace Warrior 482, 2003*

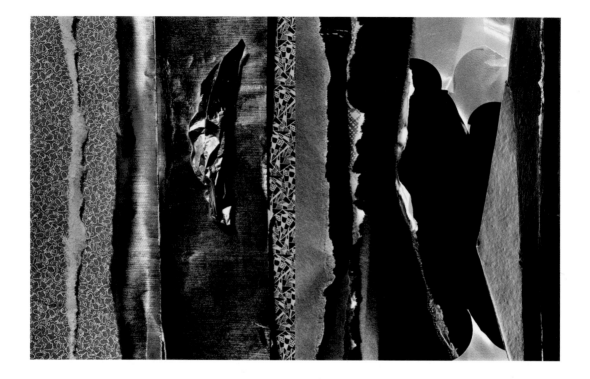

*Ahab Diptych 3, 373, 1991–92*

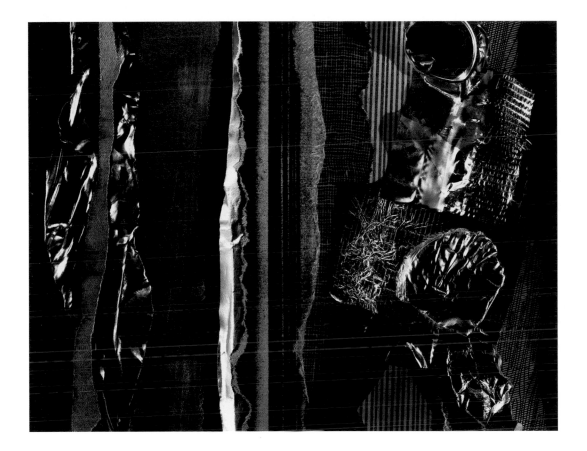

*Peace Warrior (Don Quixote) 506, 2003*

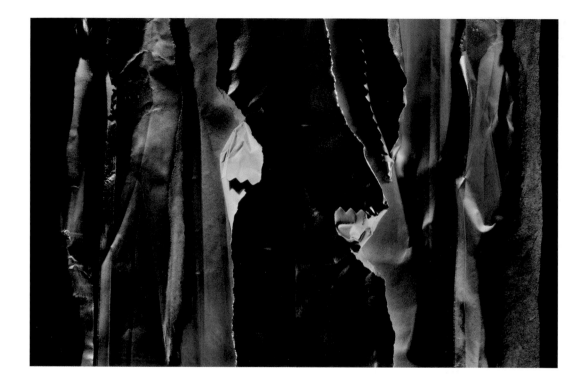

*Heidi's Garden Diptych 127, 133, 1991*

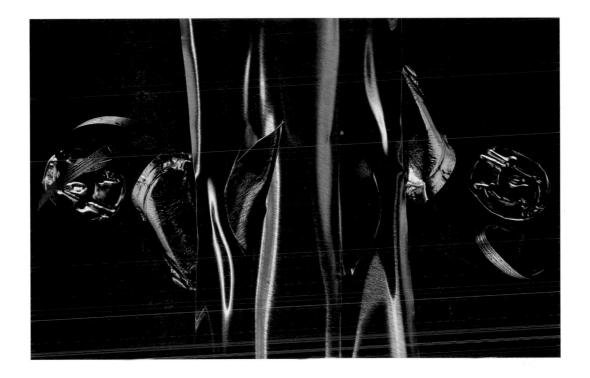

*Two of a Mind (Mulligan and Desmond) Diptych 99, 92, 2007*

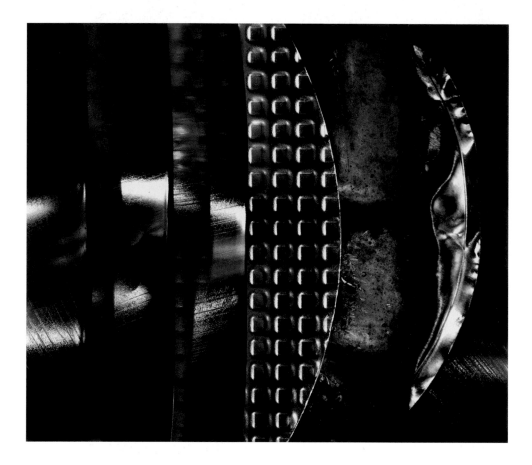

*Untitled 29, 2001*

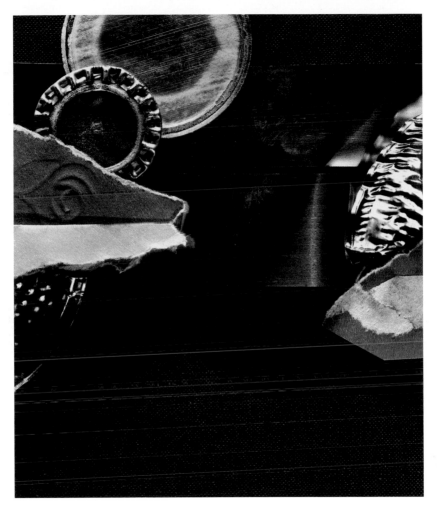

*Untitled 66, 2001*

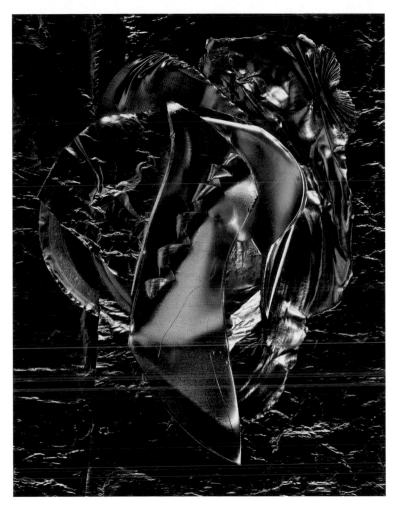

*Untitled 53, 2007*

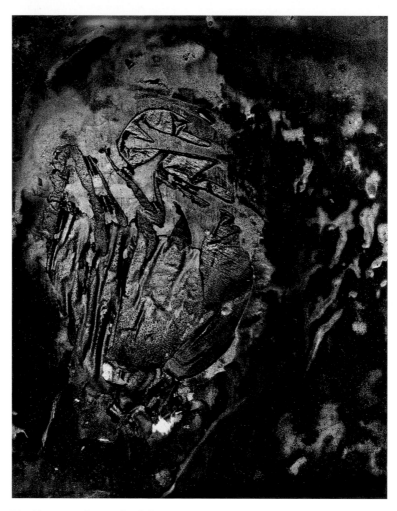

*Tar Figure – Beast-Bird, Boston, 1959*

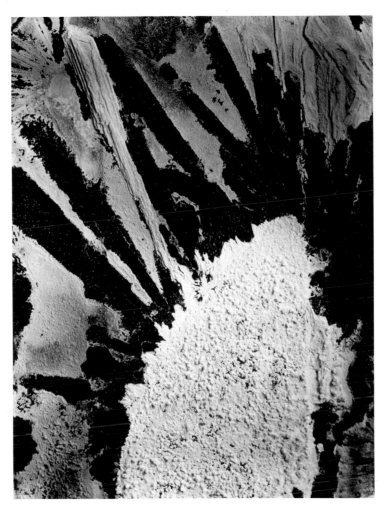

*Sulfite White Figure with Spears, 1962*

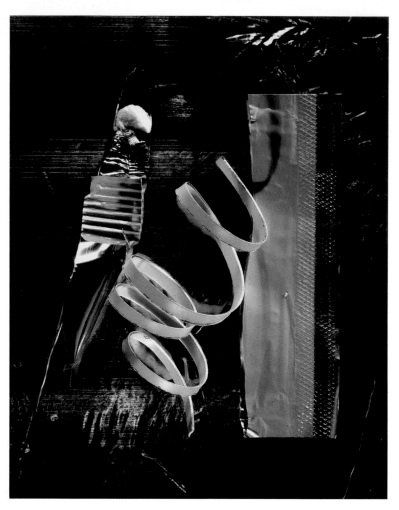

*Untitled 58, 2001*

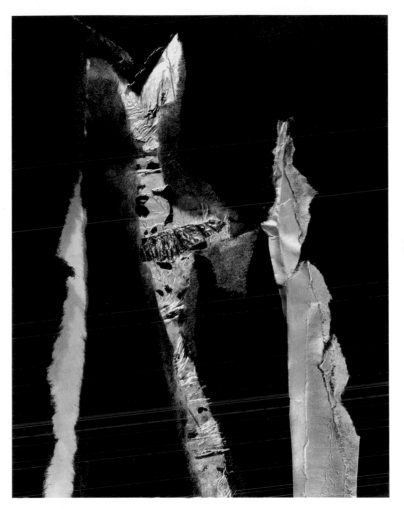

*Untitled 314, 1990*

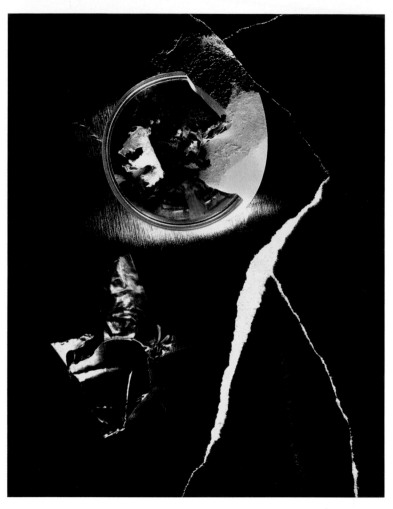

*Untitled 108, 2002*

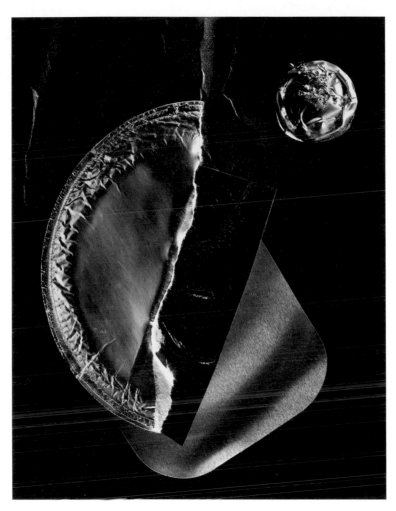

*Untitled 141, 2007*

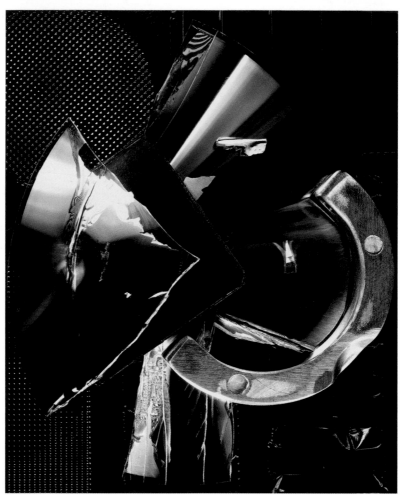

*Untitled 36, 2002*

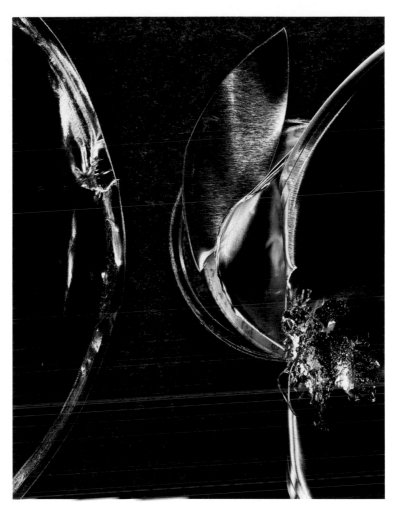

*Solitudes 78, 2004*

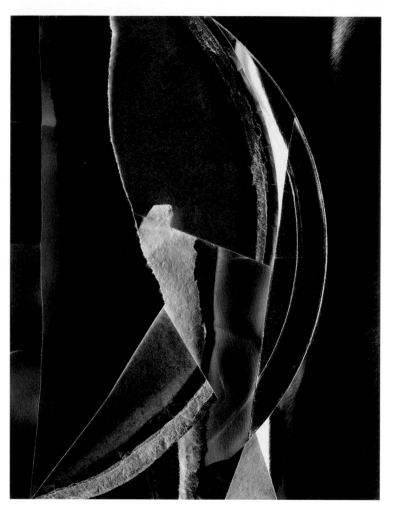

*Solitudes 110, 2004*

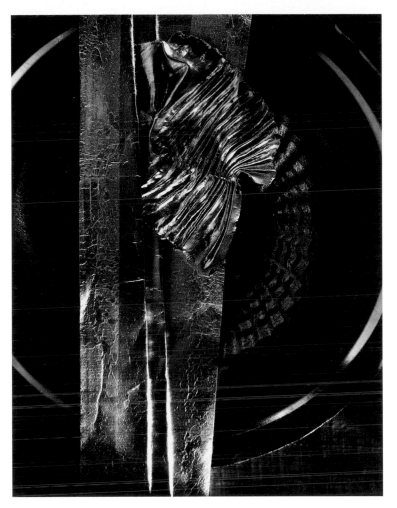

*Untitled 135, 2007*

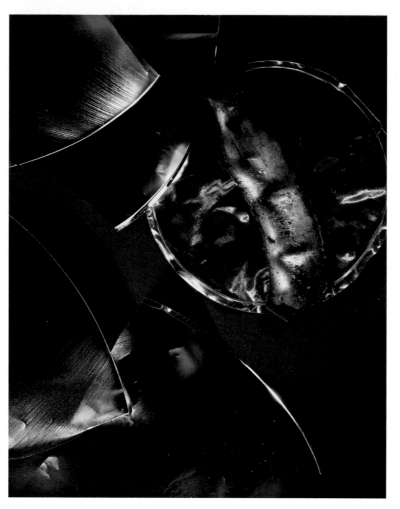

*Untitled 17, 2001*

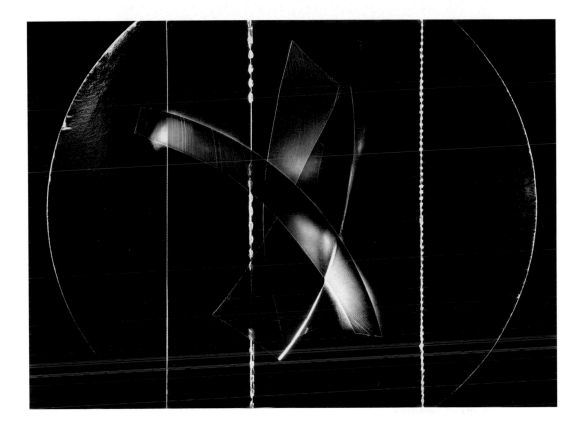

*Untitled 16, 2005*

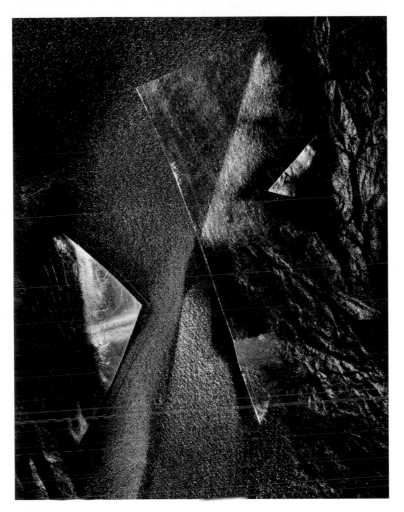

*Solitudes 342, 2004*

# Bibliography

## MONOGRAPHS

*Chiarenza: Landscapes of the Mind* (David R. Godine, Boston, 1988), with essays by Estelle Jussim and Charles Millard, and a chronology by Susan E. Cohen and William S. Johnson

*Chiarenza: Evocations* (Nazraeli Press, Tucson, 2002) with poetry by Robert Koch

*Peace Warriors of 2003* (Nazraeli Press, Tucson, 2005)

*Solitudes* (Lodima Press, Ottsville, PA, 2005)

*Interaction: Verbal/Visual* (Nazraeli Press, Portland, OR, 2006)

Chiarenza is also the author of numerous essays and of the critical biography *Aaron Siskind: Pleasures and Terrors* (Little, Brown, Boston, 1982), which received a Photographic Historical Society merit award.

See also: Stu Levy, *Cranial Czar, Eh!* (Nazraeli Press, Tucson, 2005) – Chiarenza is the subject.

## Public Collections

Los Angeles County Museum of Art; Smithsonian American Art Museum (Washington, DC); Philadelphia Museum of Art; Museum of Modern Art (New York); Art Institute of Chicago; Cleveland Museum of Art; Minneapolis Institute of Arts; Museum of Fine Arts, Boston; The National Gallery of Art (Washington, DC); Museum of Fine Arts (Houston); San Francisco Museum of Modern Art; Amon Carter Museum (Fort Worth); The Getty Museum (Los Angeles); Santa Barbara Museum of Art (CA); Tampa Museum of Art; George Eastman House (Rochester, NY); Center for Creative Photography (Tucson); Harvard University Art Museums; Worcester Art Museum (MA); Museum of Art (Princeton University); Yale University Art Gallery; RISD Museum of Art (Providence, RI); Hallmark Fine Art Collection at Nelson-Atkins Museum of Art (Kansas City, MO); The Chrysler Museum of Art (Norfolk, VA); Krannert Art Museum (IL); Rose Art Museum (Brandeis University); Ackland Art Museum (Chapel Hill); Museum of Contemporary Photography (Chicago); Exchange National Bank (Chicago); Museum of Art (St. Petersburg, FL); International Center of Photography (New York); Grunwald Collection (UCLA); Bibliothèque Nationale de France (Paris, France); Mead Museum of Art (Amherst, MA); New Orleans Museum of Art, Addison Gallery of American Art (Andover, MA); Mount Holyoke College Art Museum; Smith College Museum of Art; University of Iowa Museum of Art; The Colby College Art Museum (Waterville, ME); The Currier Gallery of Art (Manchester, NH); The Art Gallery of Ontario (Toronto); Ryerson University (Toronto, Canada); The Photography Archive/University of Louisville (KY); LaSalle National Bank Collection (Chicago); DeCordova Museum (Lincoln, MA); The Fitchburg Art Museum (MA); Shadai Gallery (Tokyo, Japan); Kiyosato Museum of Photographic Arts (Yamanashi, Japan); and others.

A NOTE ON THE TYPE

PICTURES COME FROM PICTURES *has been set in Mentor Sans, a type designed by Michael Harvey for Monotype. An accomplished designer of typefaces, Harvey began his career as a letter-carver, working as an assistant to Reynolds Stone in the late 1950s. He designed his first dust-jackets in 1957, moving on to design his first type, Zephyr, in 1961, at which time he also began teaching lettering arts. Awarded the MBE for services to art in 2001, Harvey remains a prolific designer and continues to carve inscriptional lettering as well.* ⁚⁚⁚ *With its meticulous drawing and strong calligraphic vocabulary, the Mentor Sans types reveal a close study of the work of Eric Gill and Hermann Zapf, yet their stylish letterforms — especially those of the vibrant italic — are very much in tune with a contemporary typographic sensibility.*

DESIGN AND COMPOSITION BY CARL W. SCARBROUGH